DesignOriginals

Creative Coloring
Mandala
Expressions

Valentina Harper

DESIGN ORIGINALS
an Imprint of Fox Chapel Publishing
www.d-originals.com

Basic Color Ideas

In order to truly enjoy this coloring book, you must remember that there is no wrong way—or right way—to paint or use color. My drawings are created precisely so that you can enjoy the process no matter what method you choose to use to color them!

The most important thing to keep in mind is that each illustration was made to be enjoyed as you are coloring, to give you a period of relaxation and fun at the same time. Each picture is filled with details and forms that you can choose to color in many different ways. I value each person's individual creative process, so I want you to play and have fun with all of your favorite color combinations.

As you color, you can look at each illustration as a whole, or you can color each part as a separate piece that, when brought together, makes the image complete. That is why it is up to you to choose your own process, take your time, and, above all, enjoy your own way of doing things.

To the right are a few examples of ways that you can color each drawing.

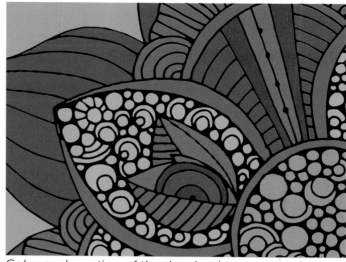

Color each section of the drawing (every general area, not every tiny shape) in one single color.

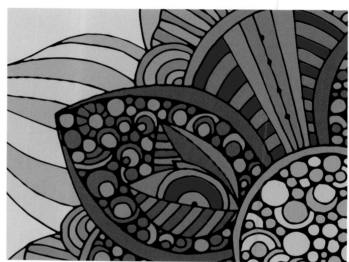

Within each section, color each detail (small shape) in alternating colors.

Leave some areas white to add a sense of space and lightness to the illustration.

Basic Color Tips

As an artist, I love to mix techniques, colors, and different mediums when it comes time to add color to my works of art. And when it comes to colors, the brighter the better! I feel that with color, illustrations take on a life of their own.

Remember: when it comes to painting and coloring, there are no rules. The most fun part is to play with color, relax, and enjoy the process and the beautiful finished result.

Feel free to mix and match colors and tones. Work your way from primary colors to secondary colors to tertiary colors, combining different tones to create all kinds of different effects. If you aren't familiar with color theory, below is a quick, easy guide to the basic colors and combinations you will be able to create.

Primary colors: These are the colors that cannot be obtained by mixing any other colors; they are yellow, blue, and red.

Secondary colors: These colors are obtained by mixing two primary colors in equal parts; they are green, purple, and orange.

Tertiary colors: These colors are obtained by mixing one primary color and one secondary color.

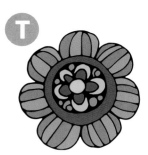

Don't be afraid of mixing colors and creating your own palettes. Play with colors—the possibilities are endless!

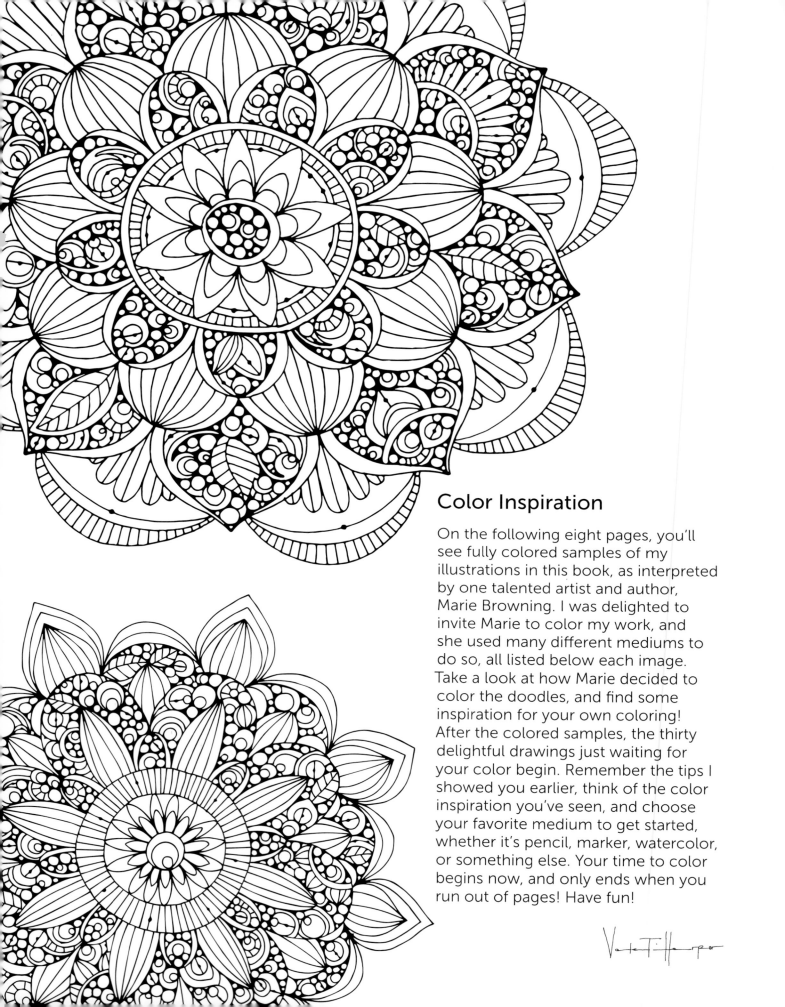

Color Inspiration

On the following eight pages, you'll see fully colored samples of my illustrations in this book, as interpreted by one talented artist and author, Marie Browning. I was delighted to invite Marie to color my work, and she used many different mediums to do so, all listed below each image. Take a look at how Marie decided to color the doodles, and find some inspiration for your own coloring! After the colored samples, the thirty delightful drawings just waiting for your color begin. Remember the tips I showed you earlier, think of the color inspiration you've seen, and choose your favorite medium to get started, whether it's pencil, marker, watercolor, or something else. Your time to color begins now, and only ends when you run out of pages! Have fun!

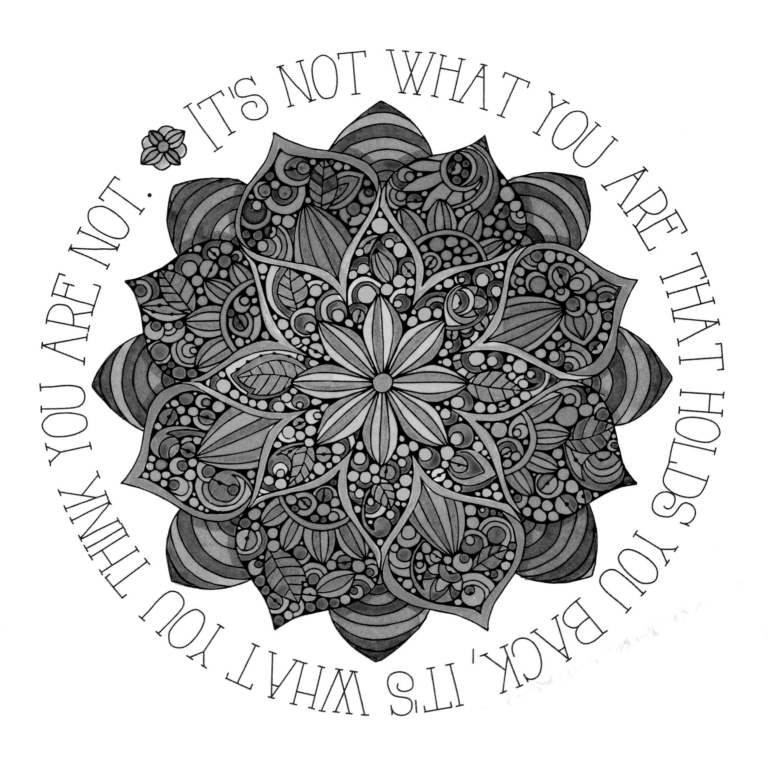

IT'S NOT WHAT YOU ARE THAT HOLDS YOU BACK, IT'S WHAT YOU THINK YOU ARE NOT. • IT'S NOT WHAT YOU ARE THAT HOLDS YOU BACK, IT'S WHAT YOU THINK YOU ARE NOT.

Watercolors (Winsor & Newton), Gel Pens (Sakura). Monochromatic tones.
Color by Marie Browning.

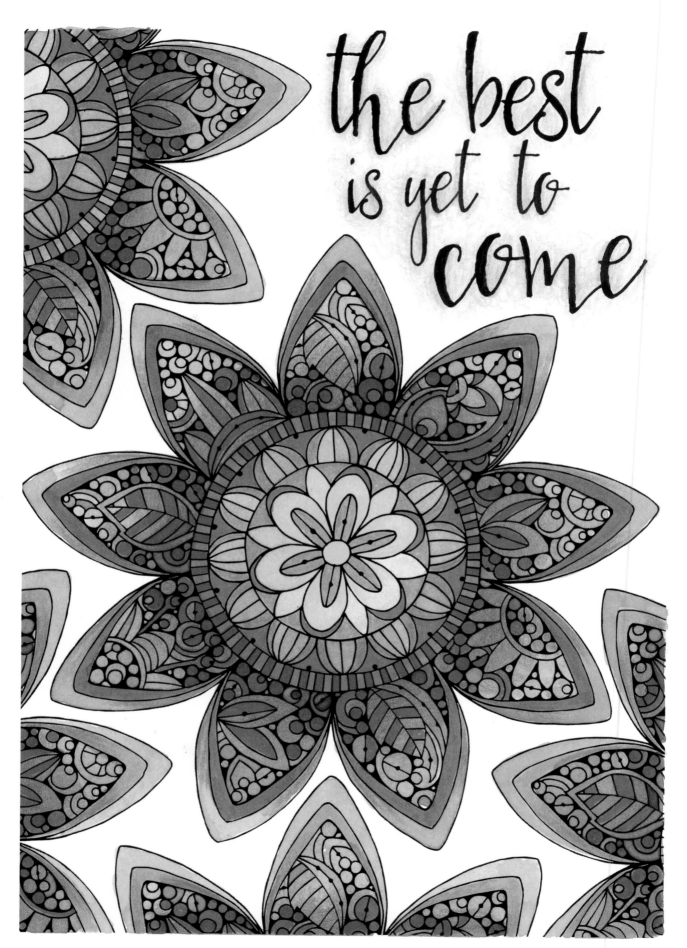

the best
is yet to
come

Watercolors (Winsor & Newton), Irojiten Colored Pencils (Tombow).
Bright tones. Color by Marie Browning.

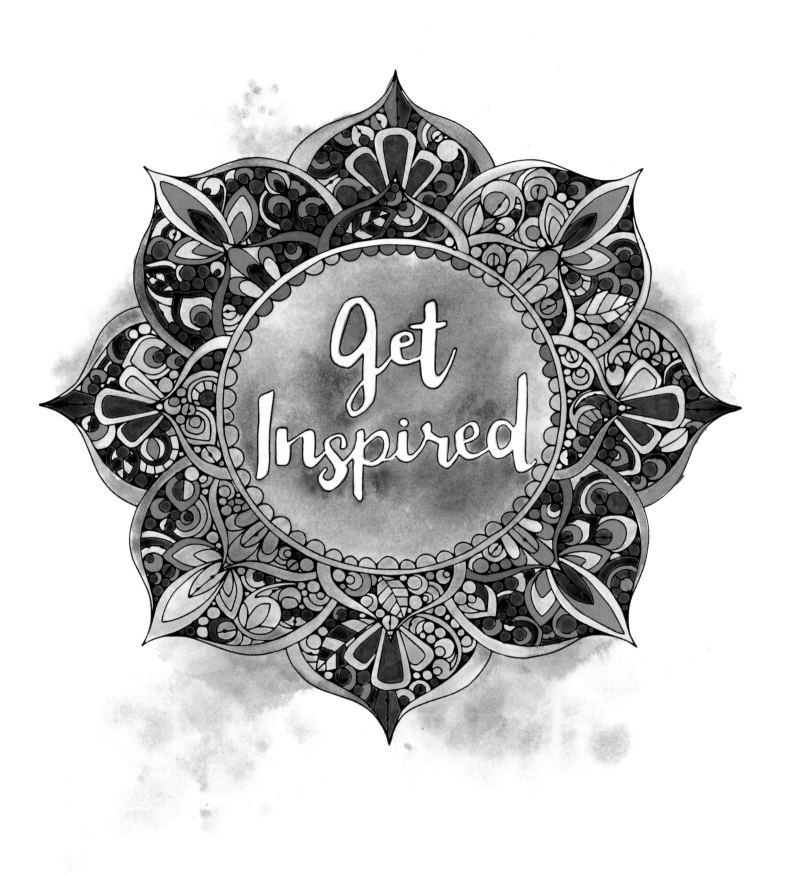

Get Inspired

Watercolors (Winsor & Newton), Gel Pens (Sakura). Jewel tones.
Color by Marie Browning.

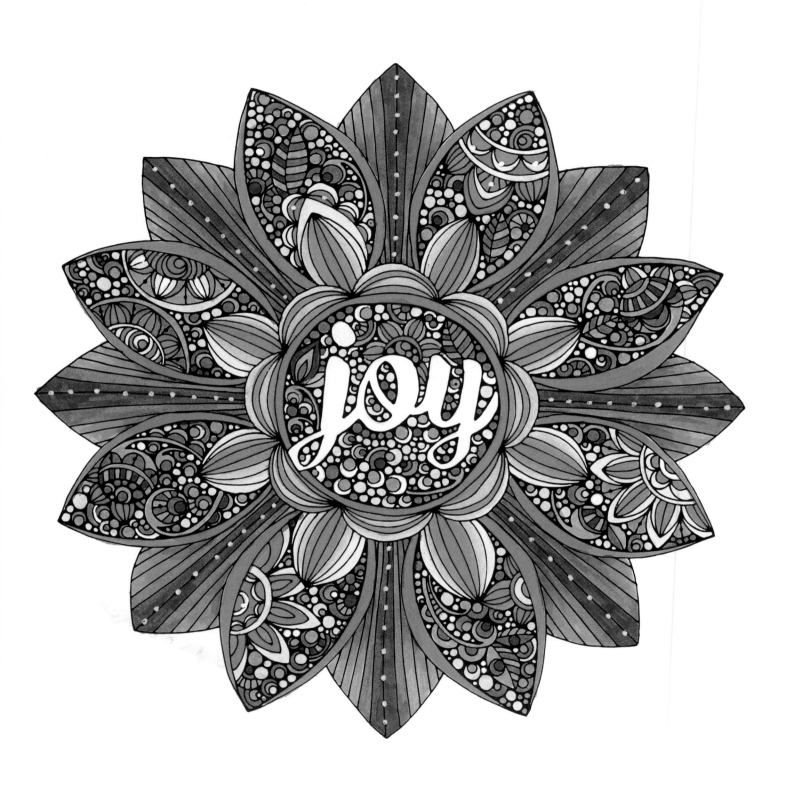

Dual Brush Markers (Tombow), Gel Pens (Sakura).
Bright tones. Color by Marie Browning.

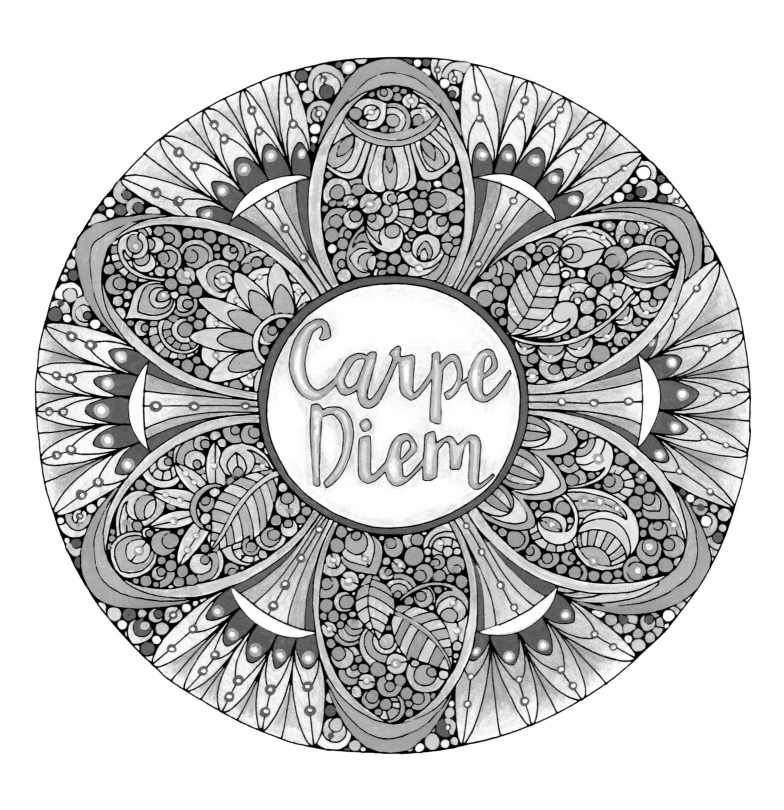

Gel Pens (Sakura), Irojiten Colored Pencils (Tombow).
Fluorescent tones. Color by Marie Browning.

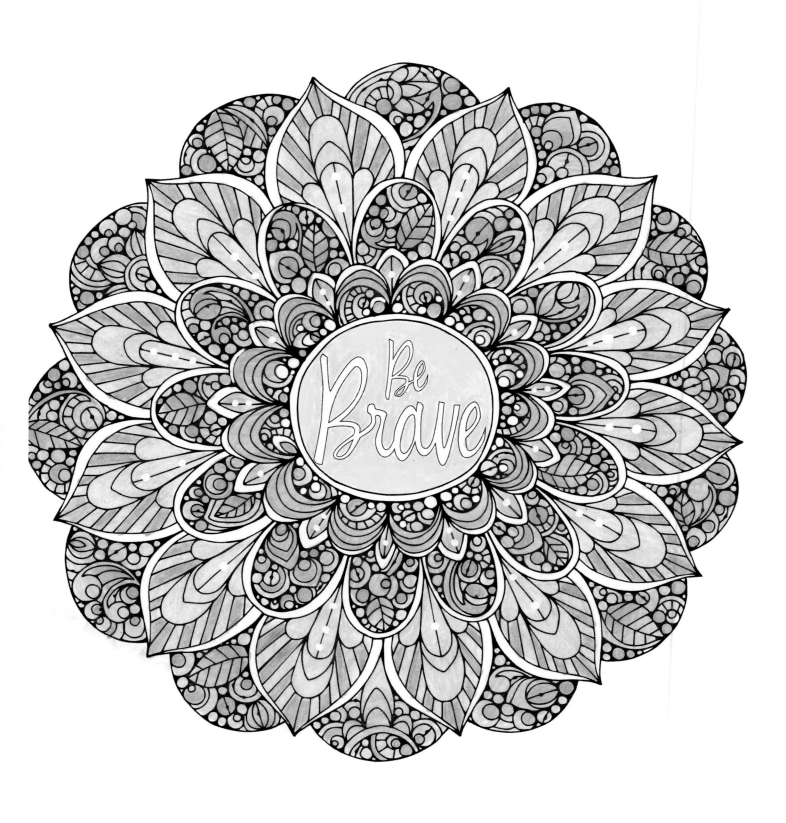

Irojiten Colored Pencils (Tombow), White Gel Pens (Sakura).
Pale tones. Color by Marie Browning.

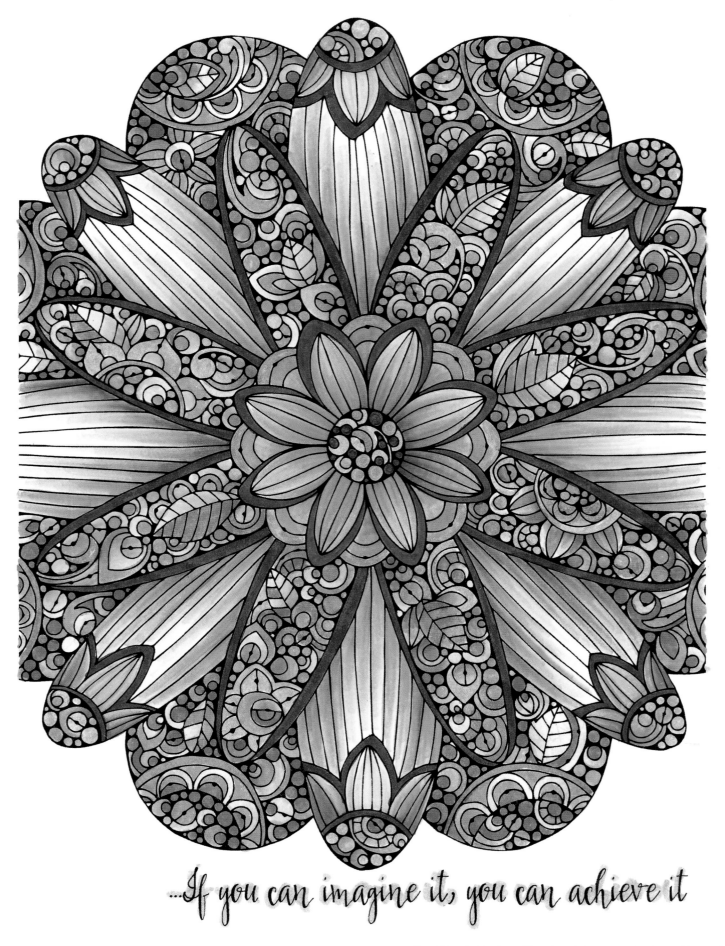

...If you can imagine it, you can achieve it

Dual Brush Markers (Tombow), Metallic Gel Pens (Sakura).
Muted complementary tones. Color by Marie Browning.

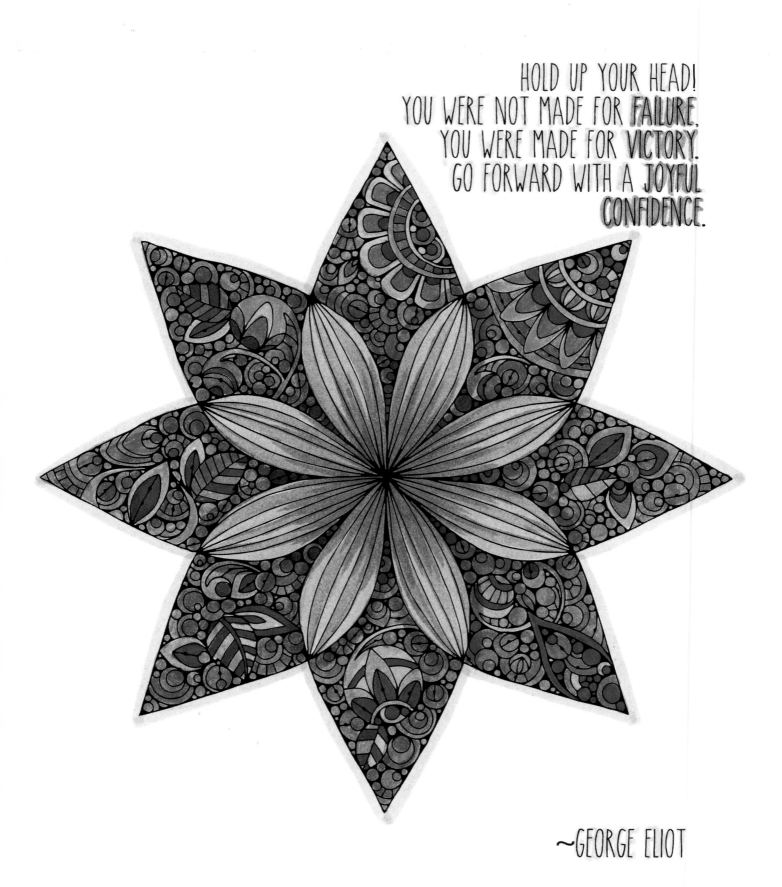

HOLD UP YOUR HEAD!
YOU WERE NOT MADE FOR FAILURE,
YOU WERE MADE FOR VICTORY.
GO FORWARD WITH A JOYFUL
CONFIDENCE.

~GEORGE ELIOT

Dual Brush Markers (Tombow). Analogous tones.
Color by Marie Browning.

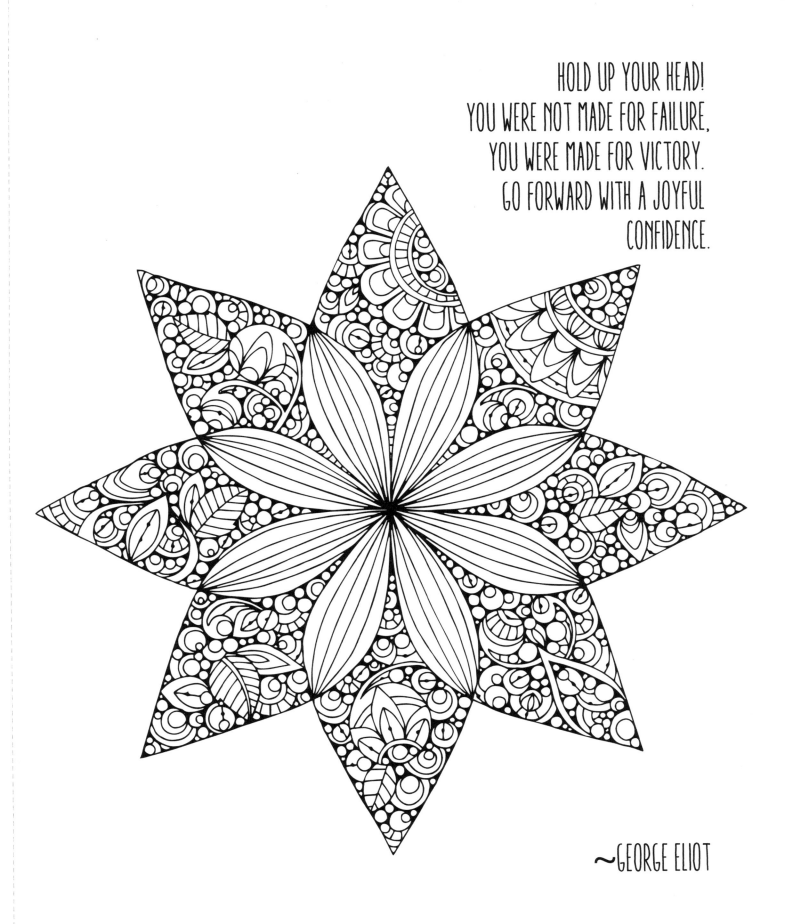

HOLD UP YOUR HEAD!
YOU WERE NOT MADE FOR FAILURE,
YOU WERE MADE FOR VICTORY.
GO FORWARD WITH A JOYFUL
CONFIDENCE.

~GEORGE ELIOT

Nothing ever goes away until it has taught us
what we need to know.

—Pema Chödrön

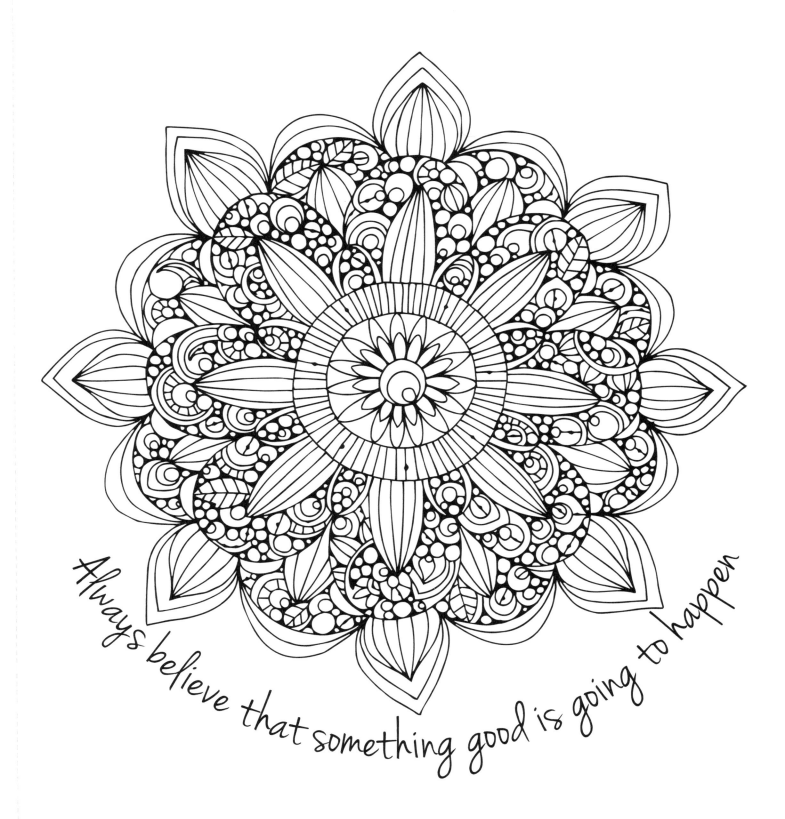

Always believe that something good is going to happen

Always find a reason to laugh. It may not
add years to your life, but will surely
add life to your years.

—Unknown

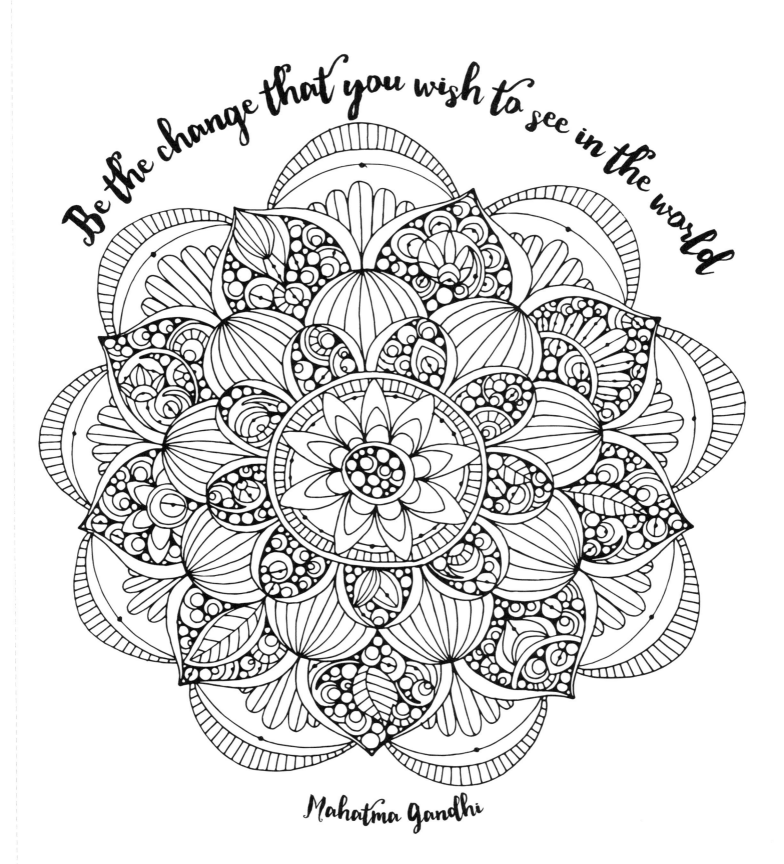

Be the change that you wish to see in the world

Mahatma Gandhi

Sometimes in the waves of change we
find our true direction.

—Unknown

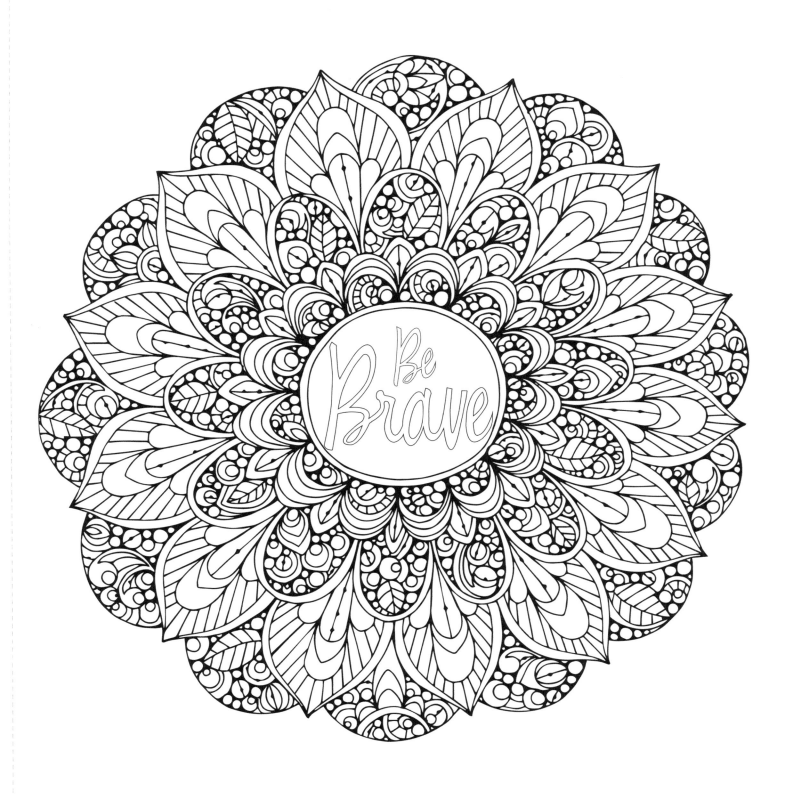

Do one thing every day that scares you.

—Mary Schmich

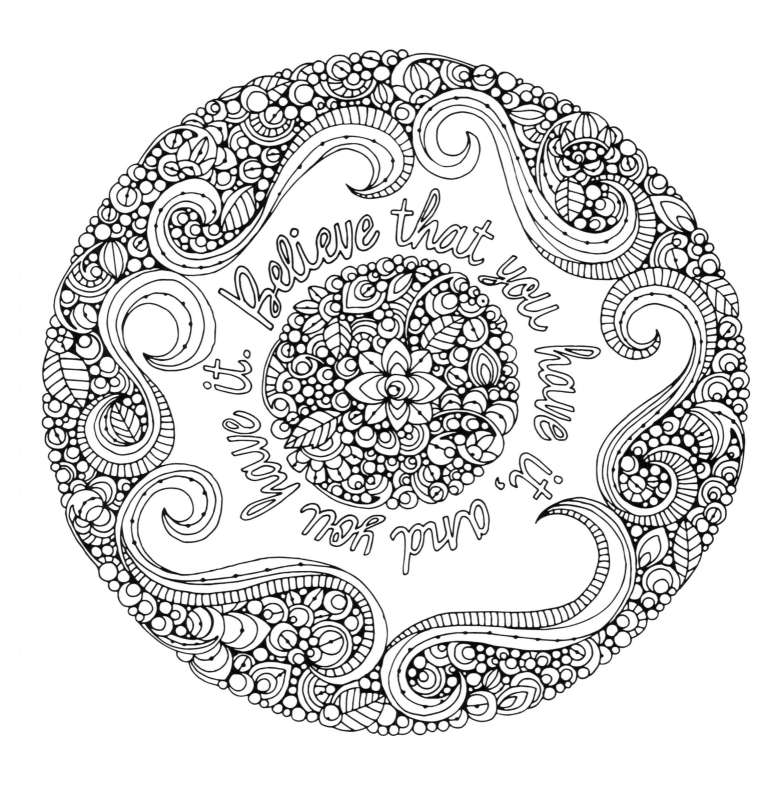

The image contains the text: "Believe that you have it, and you have it."

It is better to know and be disappointed than
to never know and always wonder.

—Unknown

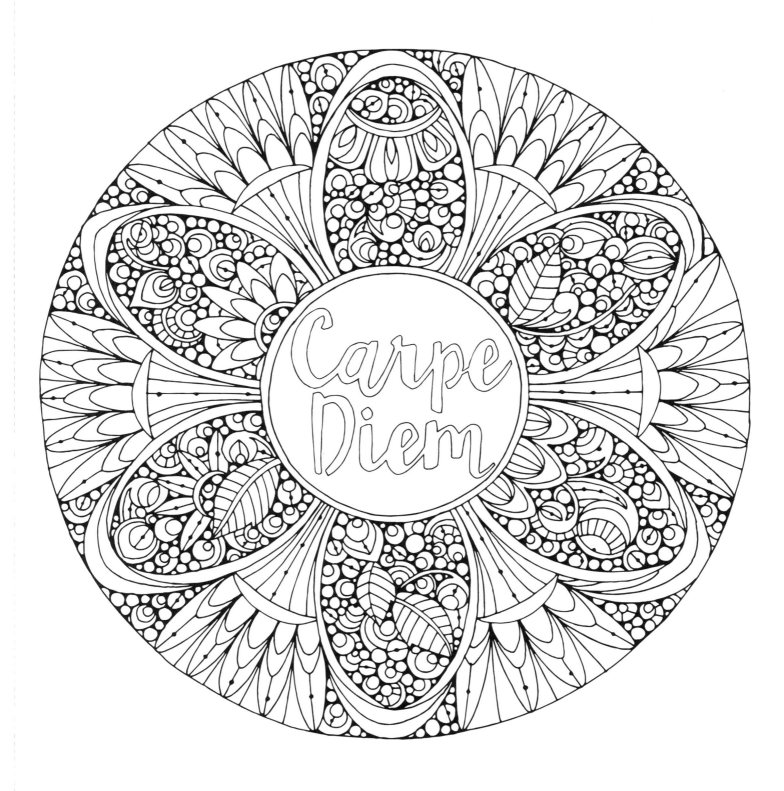

Don't wait for the perfect moment, take the moment and make it perfect.

—Unknown

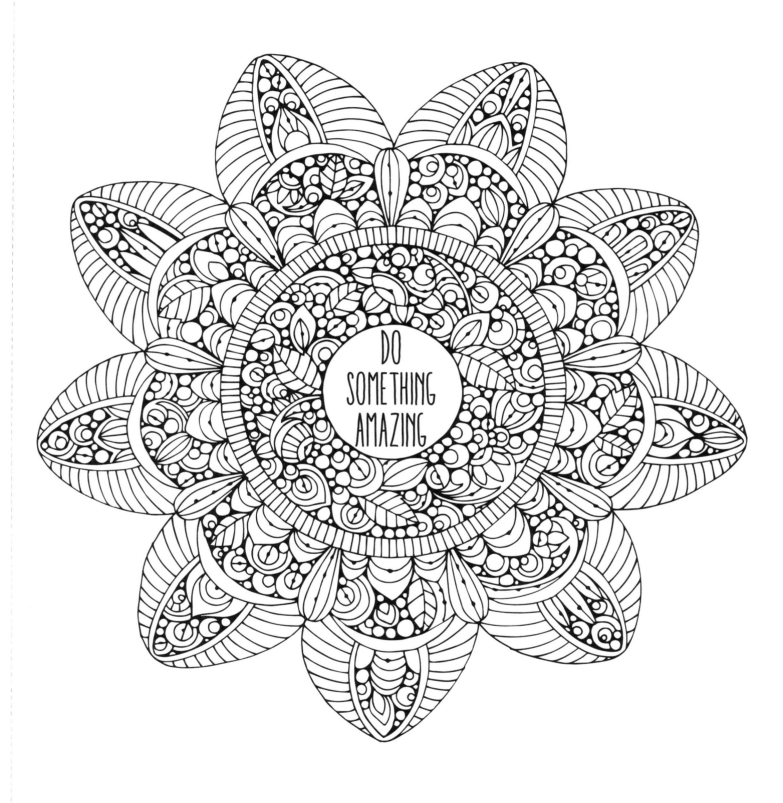

DO SOMETHING AMAZING

Never love anyone who treats you
like you're ordinary.

—Oscar Wilde

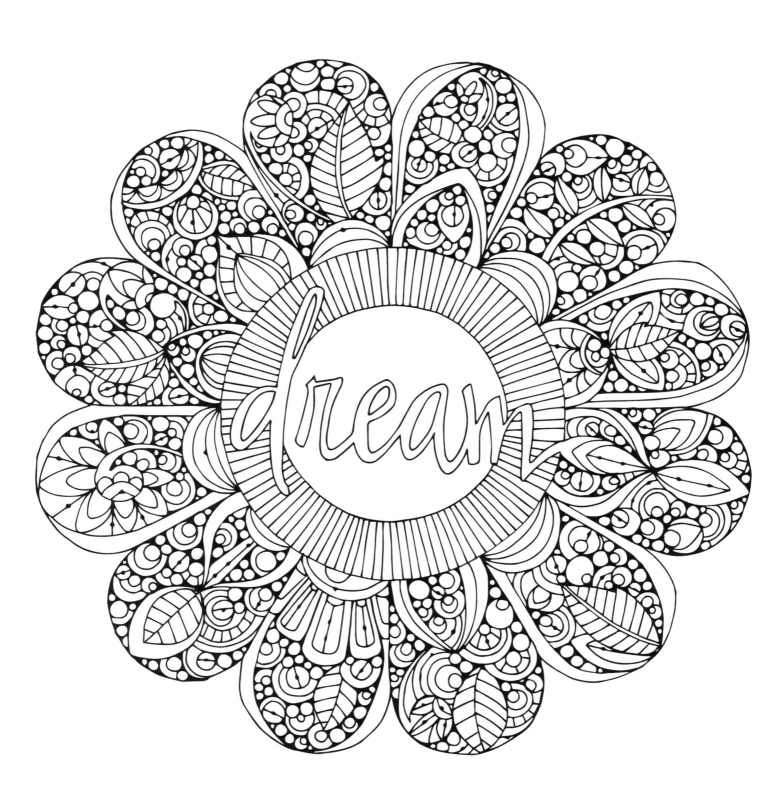

A dream is more powerful than
a thousand realities.

—Nathaniel Hawthorne

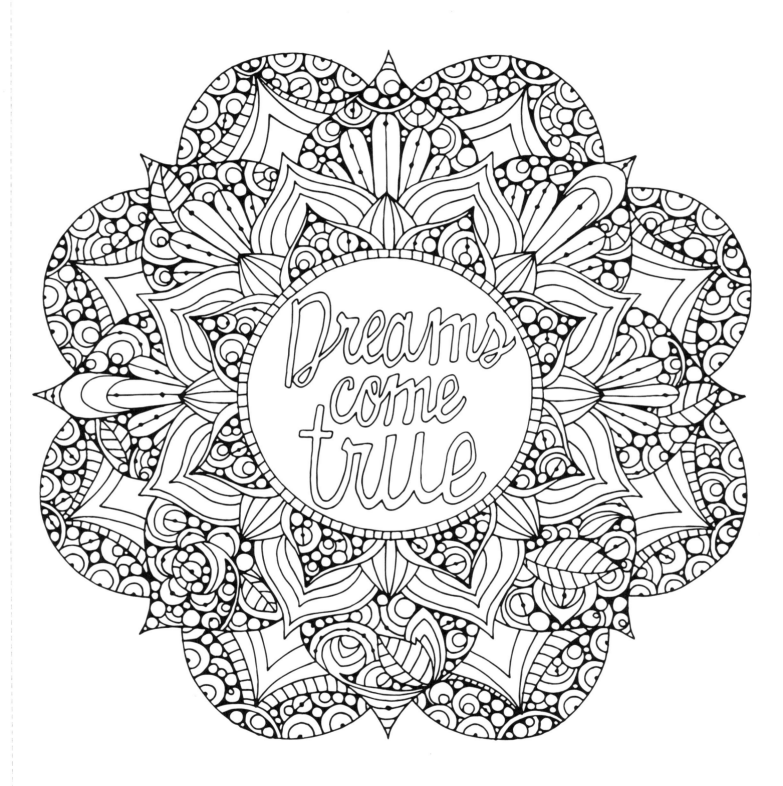

All our dreams can come true if we have the
courage to pursue them.

—Walt Disney

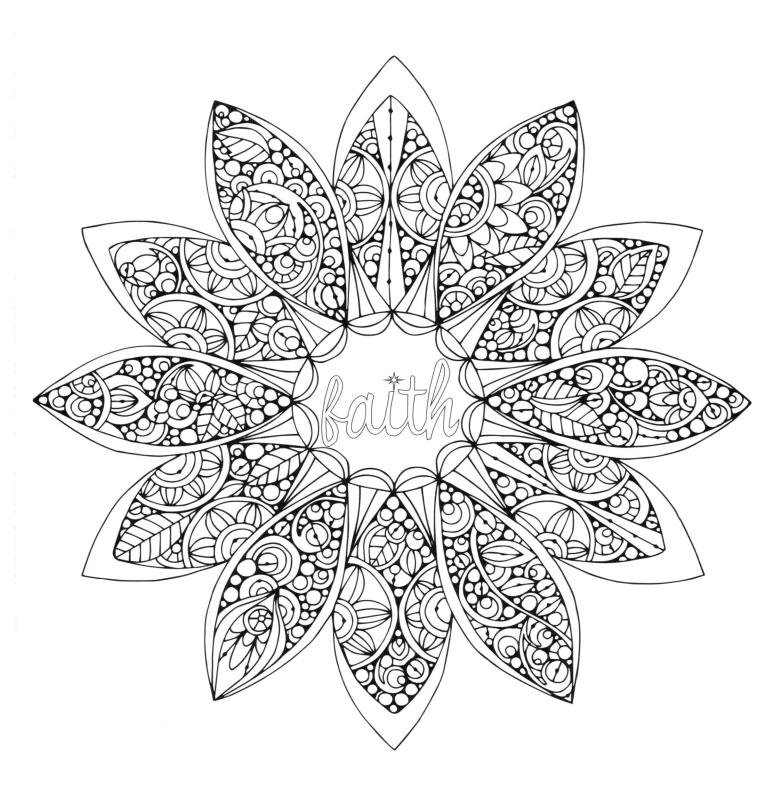

Faith is taking the first step, even when you don't see the whole staircase.

—Martin Luther King, Jr.

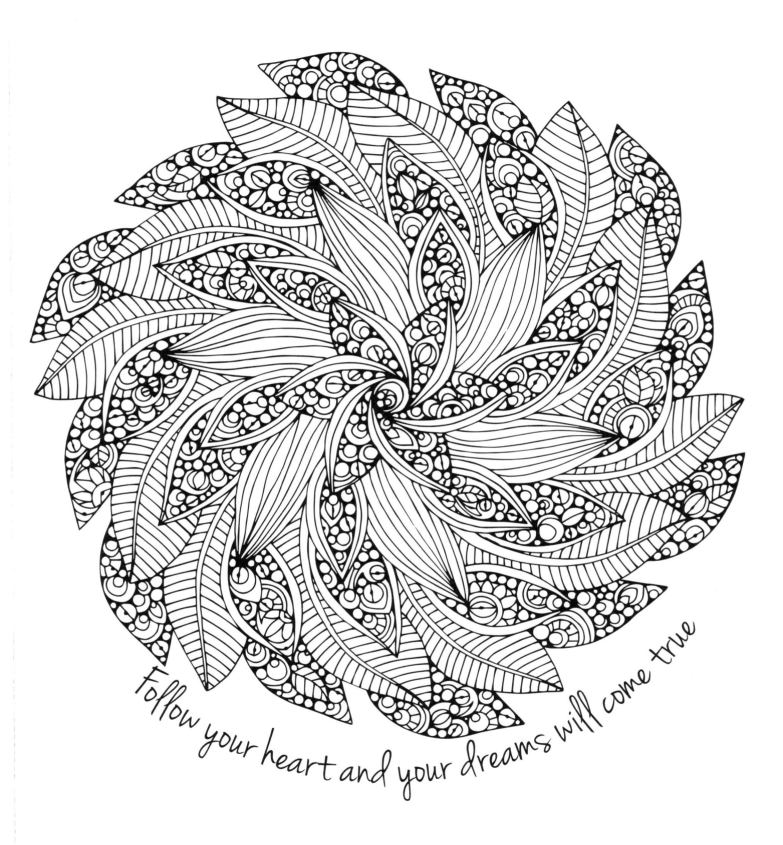

Follow your heart and your dreams will come true

Always listen to your heart, because even though it's on your left side, it's always right.

—*The Notebook*

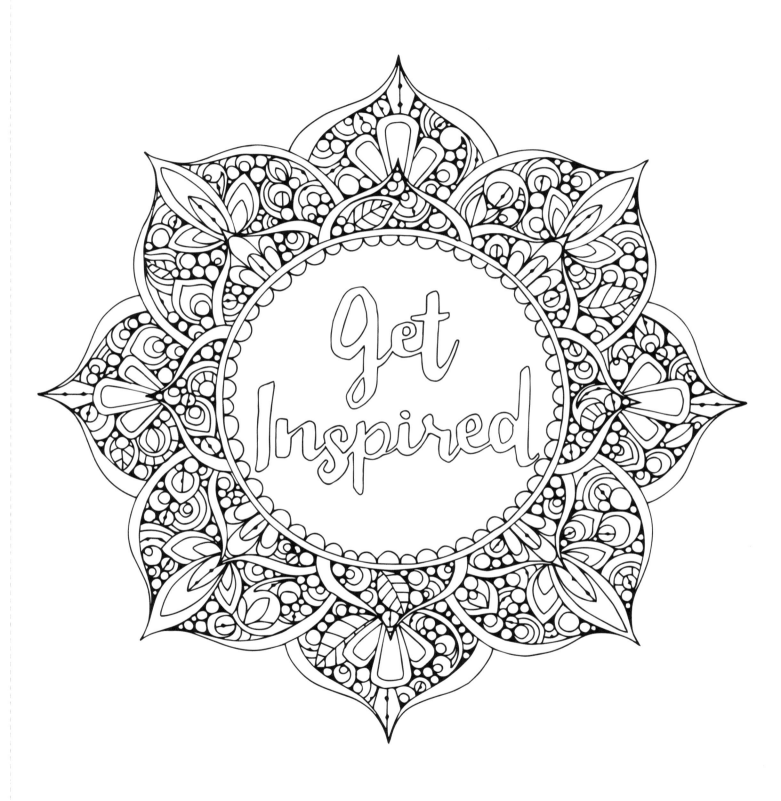

Don't stop trying just because you've
hit a wall. Progress is progress
no matter how small.

—Unknown

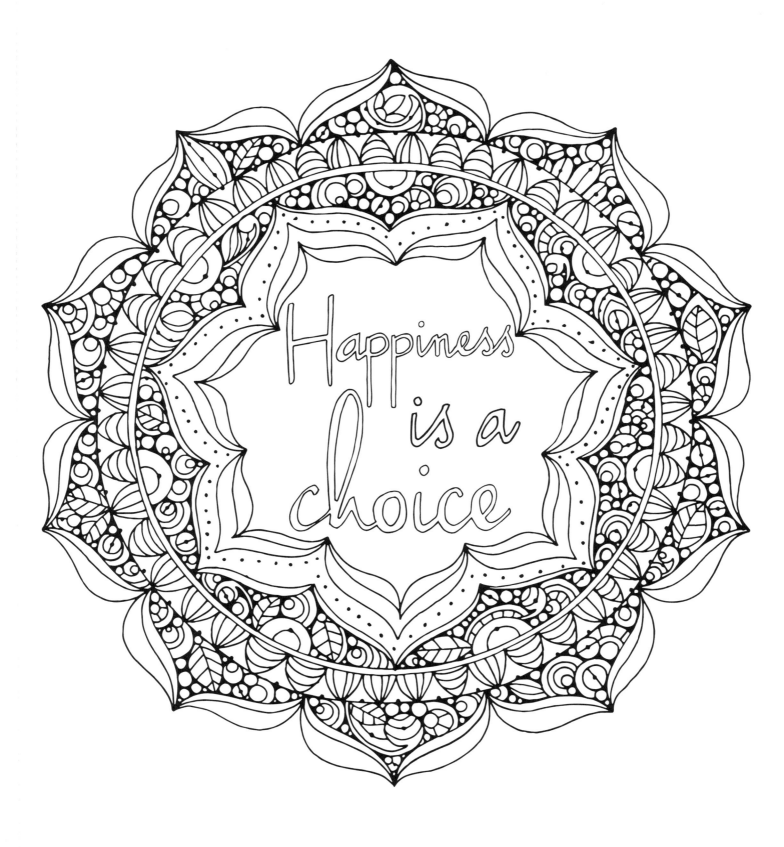

If you want to be happy, be.

—Leo Tolstoy

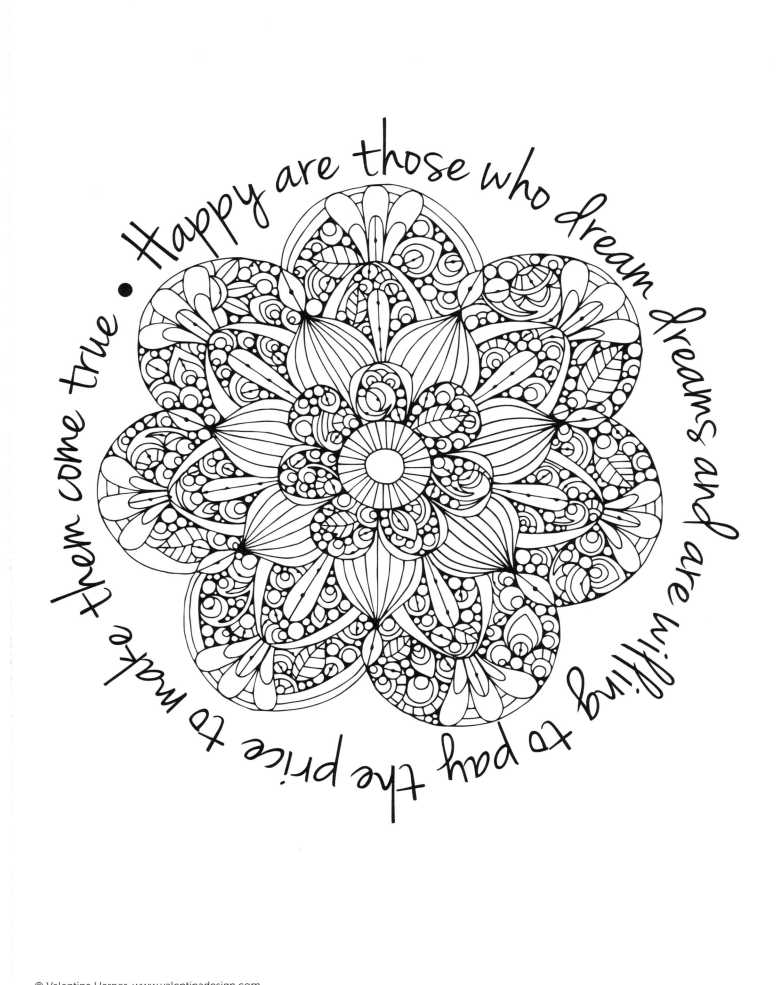

Happy are those who dream dreams and are willing to pay the price to make them come true

Happiness is not a station you arrive at,
but a manner of traveling.

—Margaret Lee Runbeck

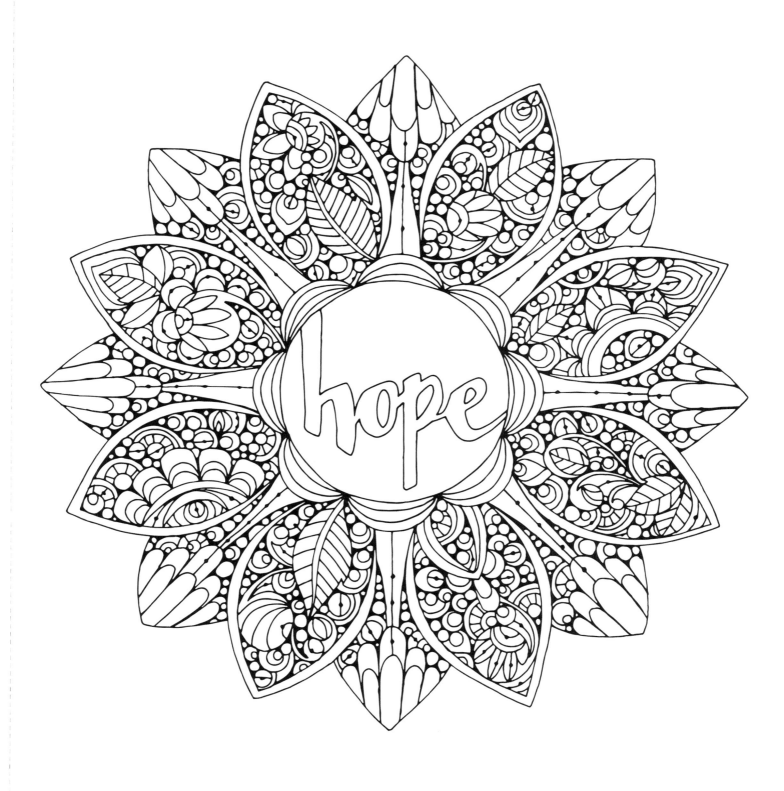

Hope is putting faith to work when
doubting would be easier.

—Thomas S. Monson

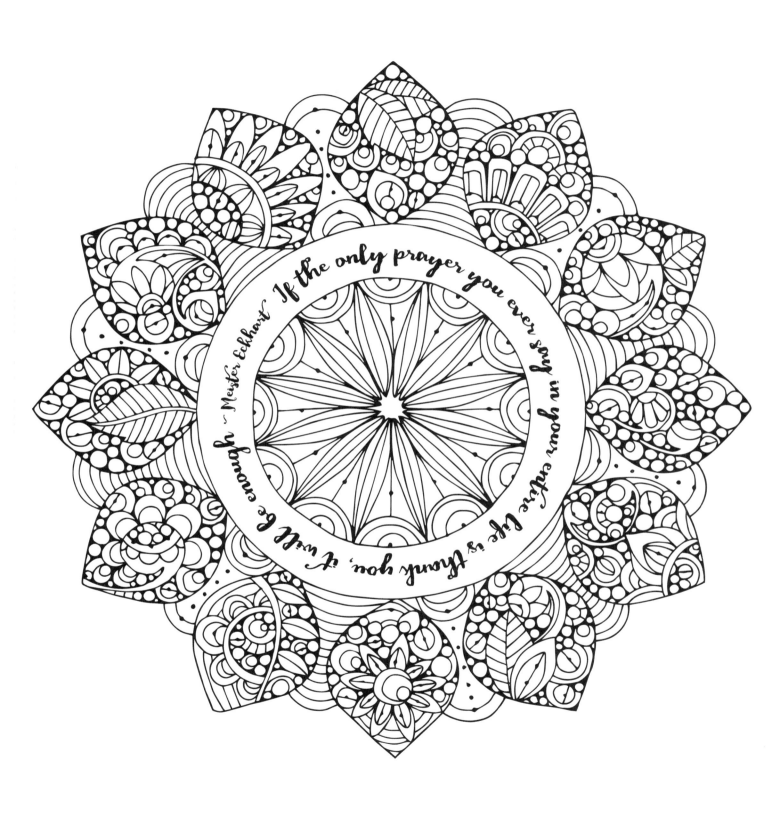

If the only prayer you ever say in your entire life is thank you, it will be enough. ~ Meister Eckhart

The real gift of gratitude is that the more grateful you are, the more present you become.

—Robert Holden

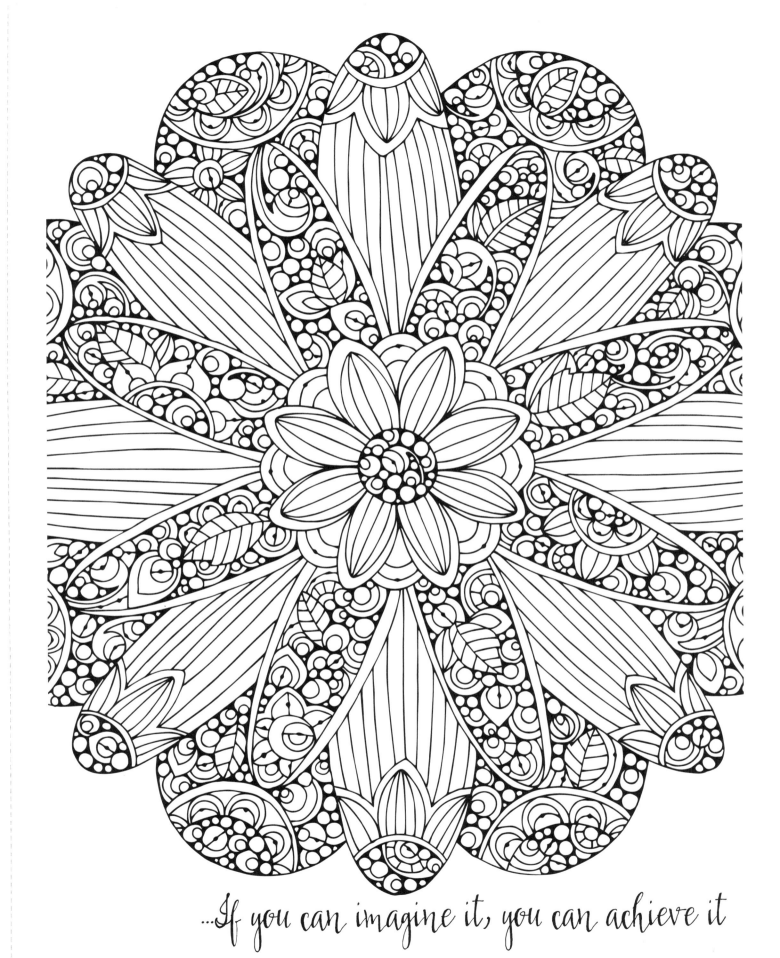

...If you can imagine it, you can achieve it

What you think, you become. What you feel, you attract. What you imagine, you create.

—Unknown

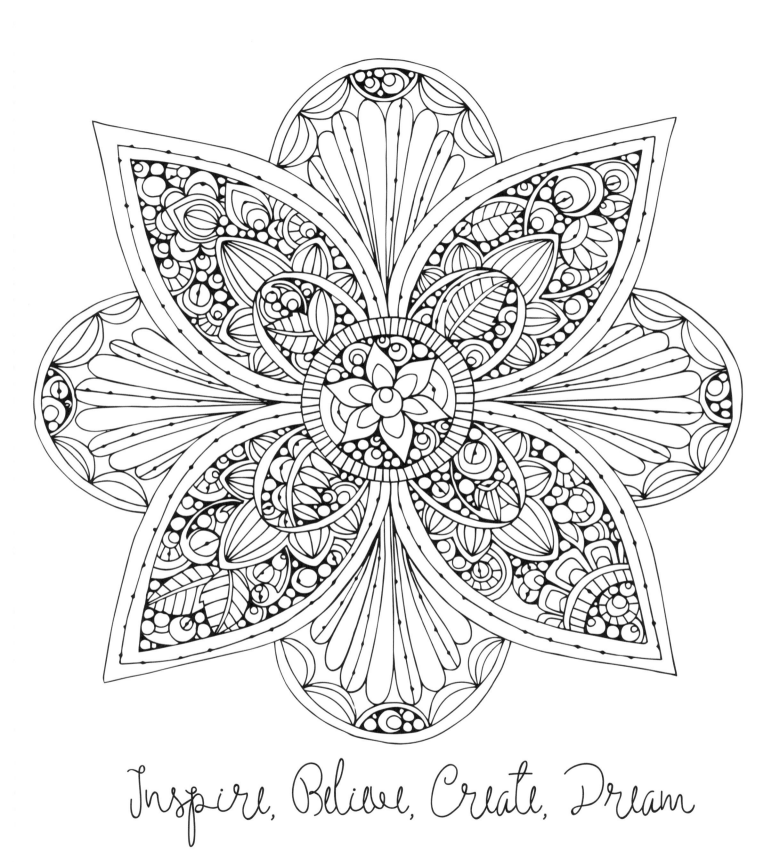

Inspire, Believe, Create, Dream

The future depends on what you do today.

—Mahatma Gandhi

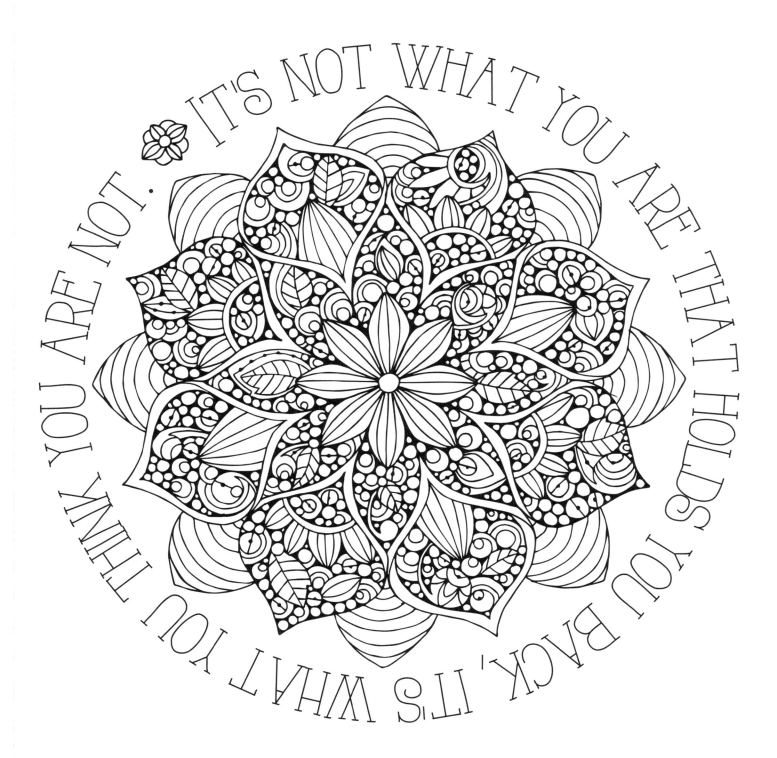

IT'S NOT WHAT YOU ARE THAT HOLDS YOU BACK, IT'S WHAT YOU THINK YOU ARE NOT.

Shoot for the moon. Even if you miss,
you'll land among stars.

—Les Brown

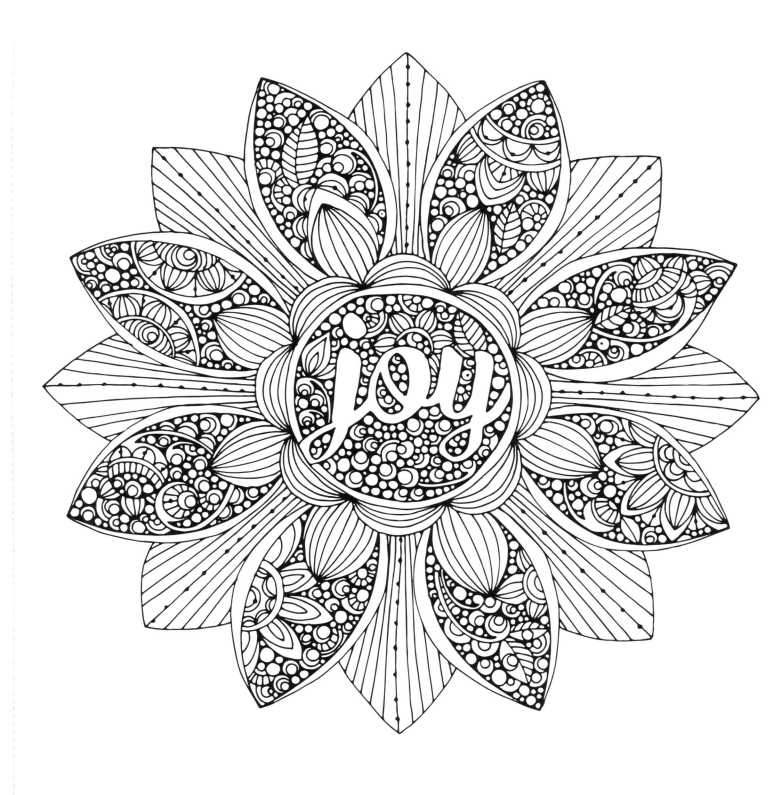

Joy is what happens to us when we
allow ourselves to recognize how
good things really are.

—Marianne Williamson

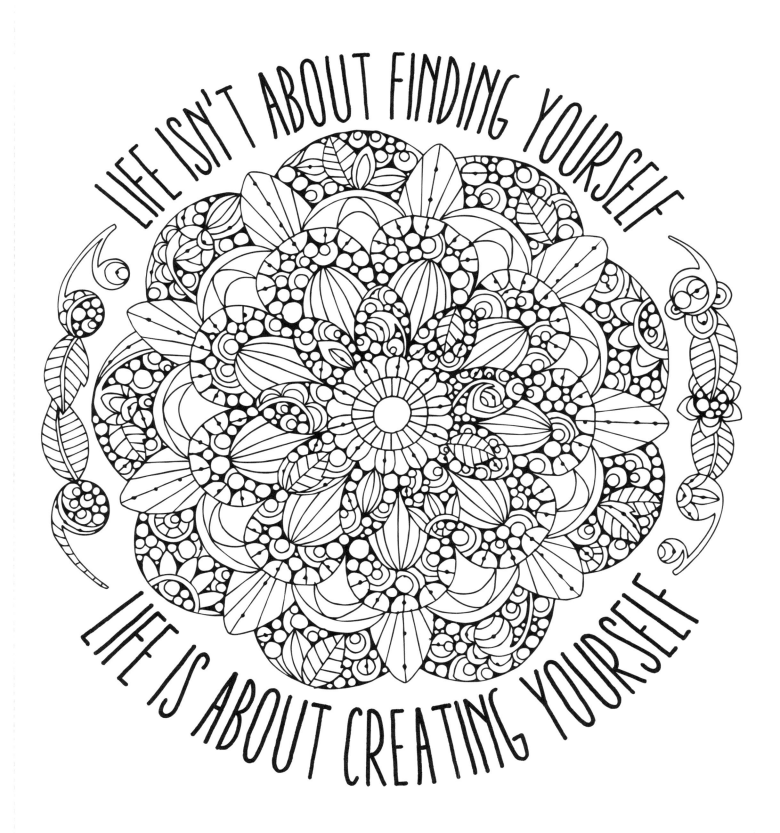

LIFE ISN'T ABOUT FINDING YOURSELF

LIFE IS ABOUT CREATING YOURSELF

~GEORGE BERNARD SHAW

The best way to predict the future
is to create it.

—Unknown

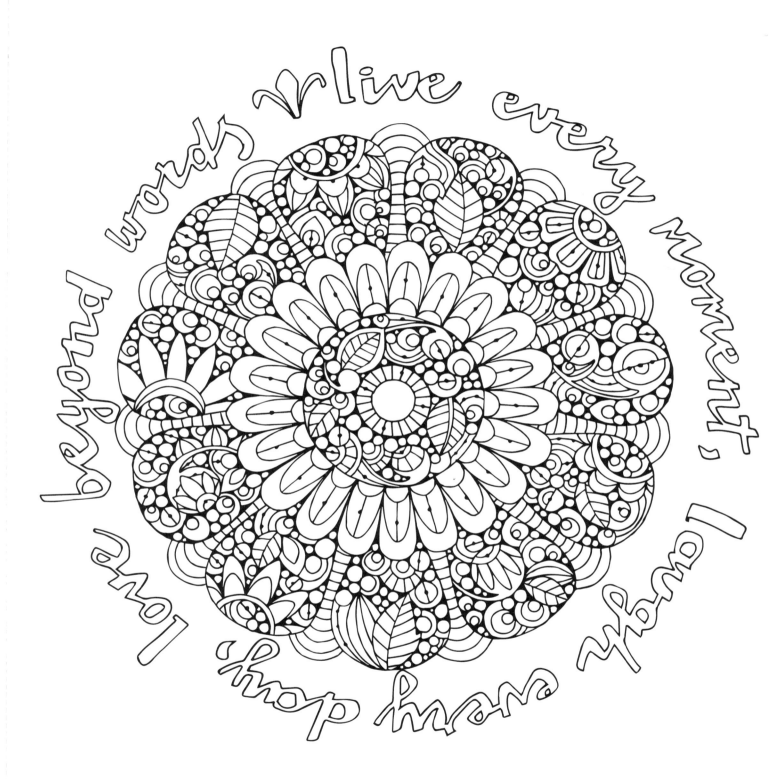

live every moment, laugh every day, love beyond words

Be in love with your life. Every minute of it.

—Jack Kerouac

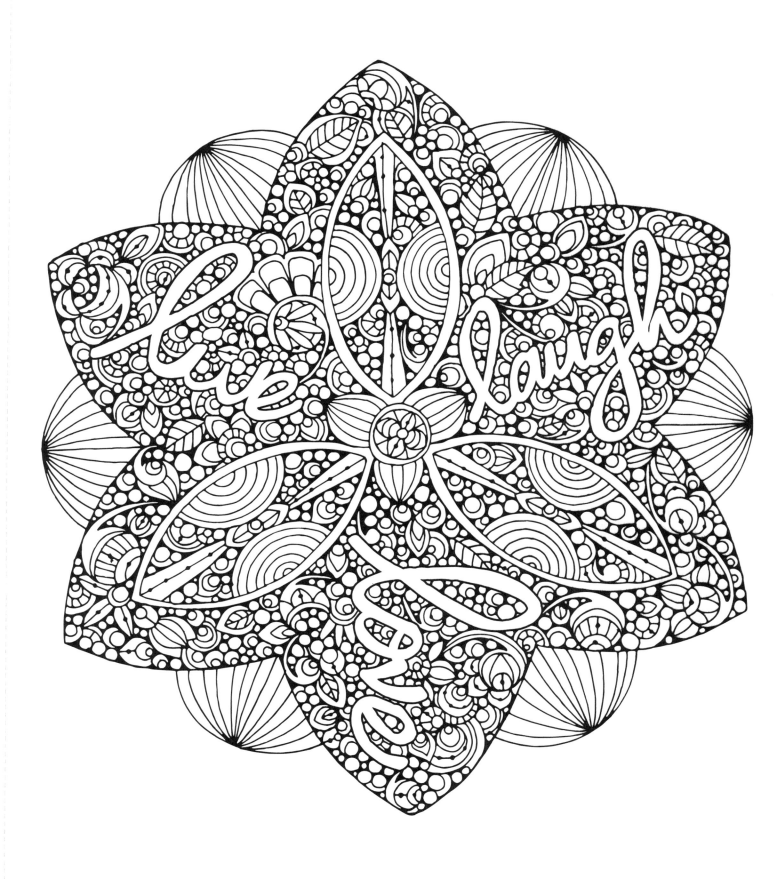

Life is too deep for words, so don't try to describe it, just live it.

—C.S. Lewis

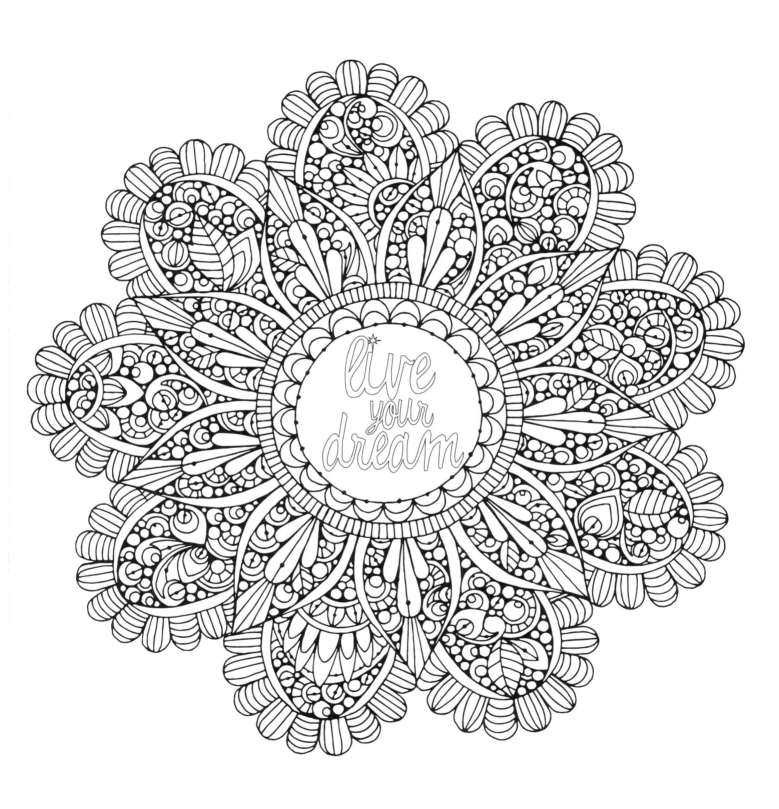

live your dream

Have the courage to follow your heart and
intuition. They somehow already know what
you truly want to become.

—Steve Jobs

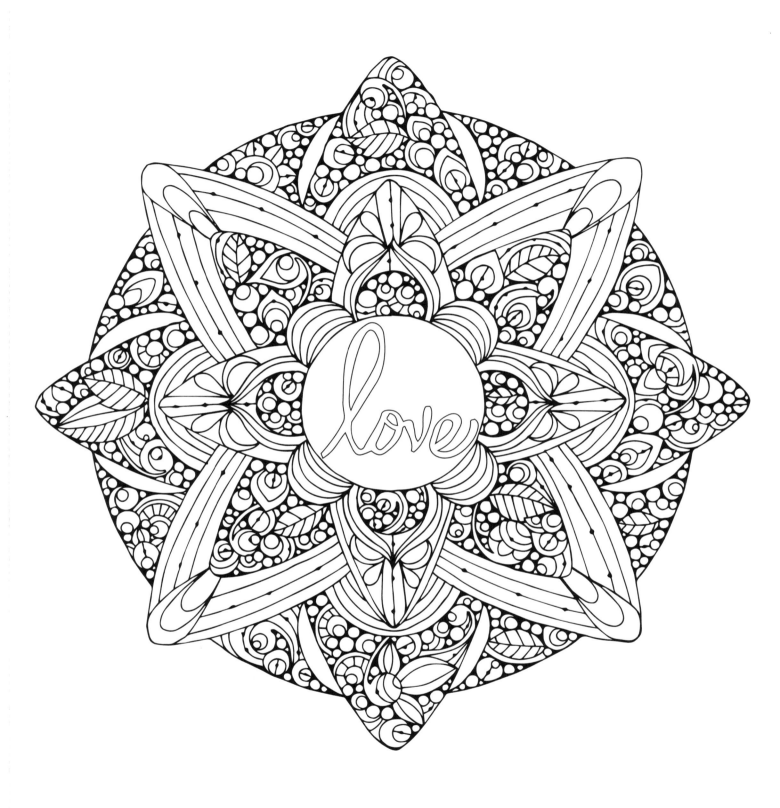

You are the finest, loveliest, tenderest, most beautiful person I have ever known, but even that is an understatement.

—F. Scott Fitzgerald

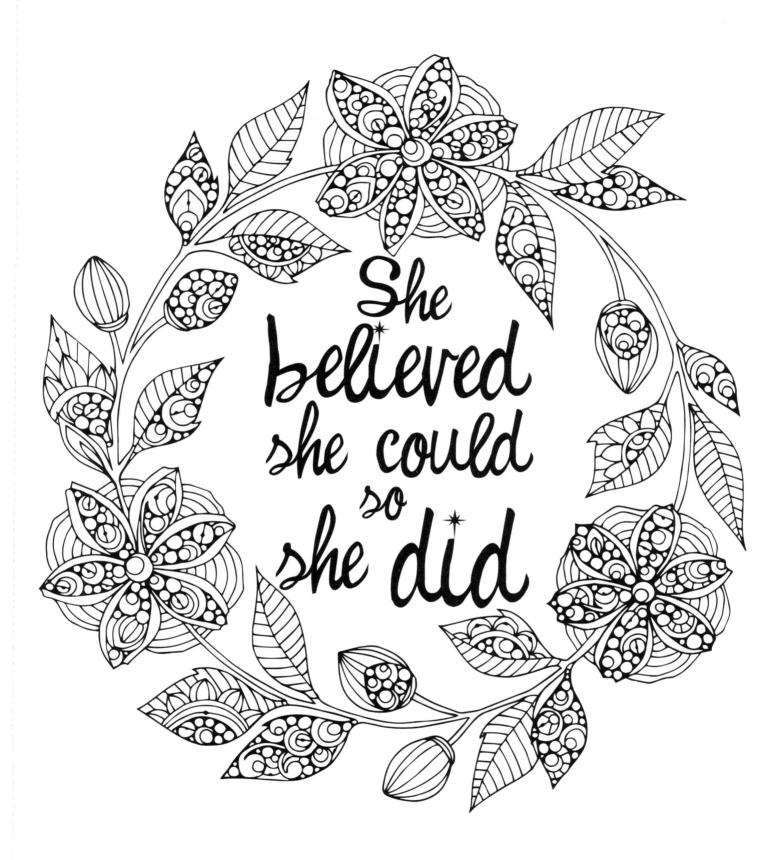

Be magnificent. Life's short. Get out there.
You can do it. Everyone can do it. Everyone.

—Andy Serkis

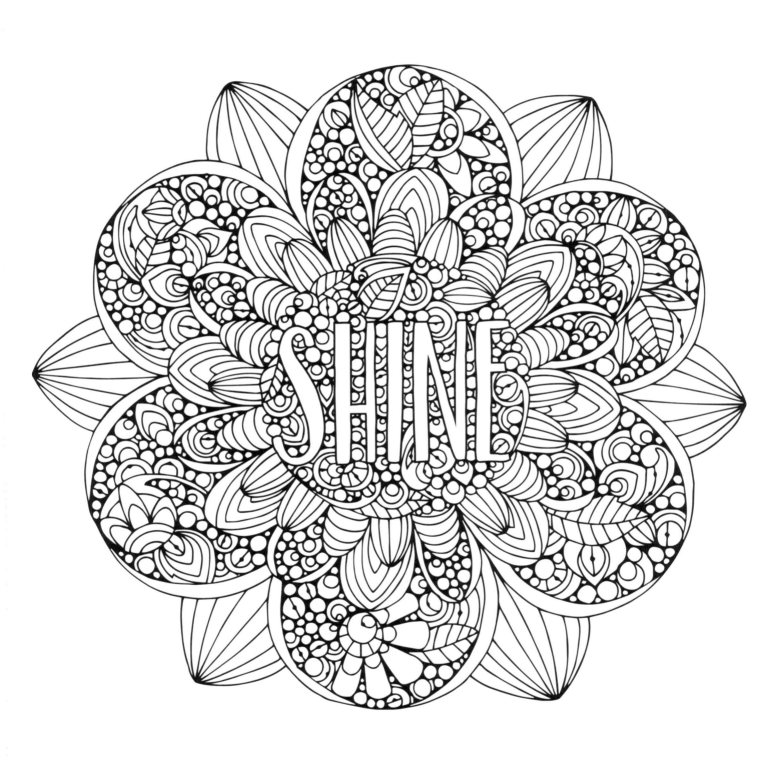

Nothing can dim the light that
shines from within.

—Maya Angelou

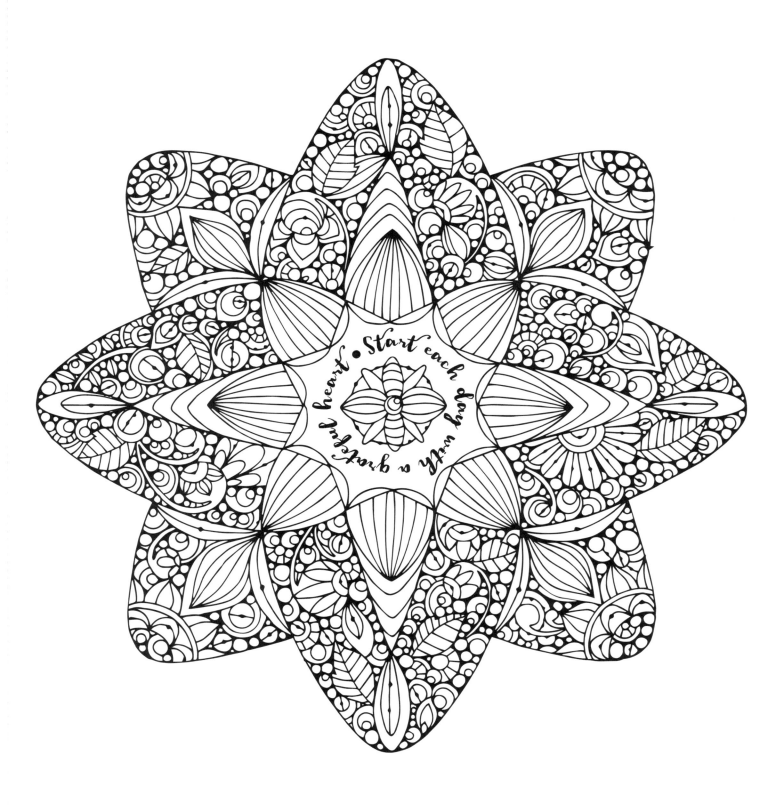

No matter what the situation is... close your eyes and think of all the things you could be grateful for in your life right now.

—Deepak Chopra

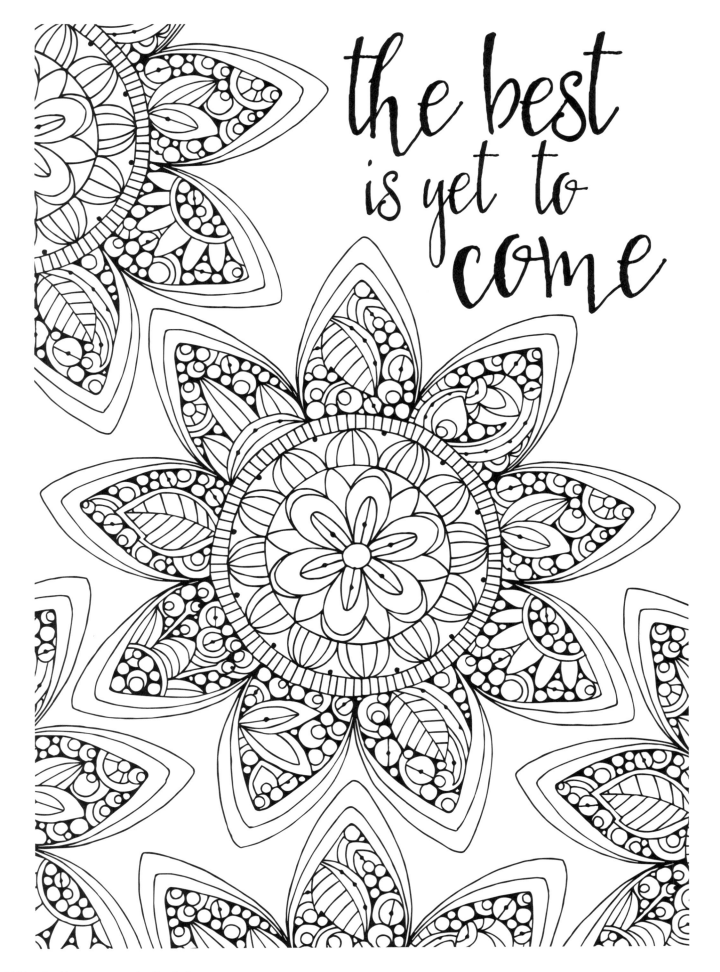

the best
is yet to
come

For my part I know nothing with any certainty,
but the sight of the stars makes me dream.

—Vincent van Gogh

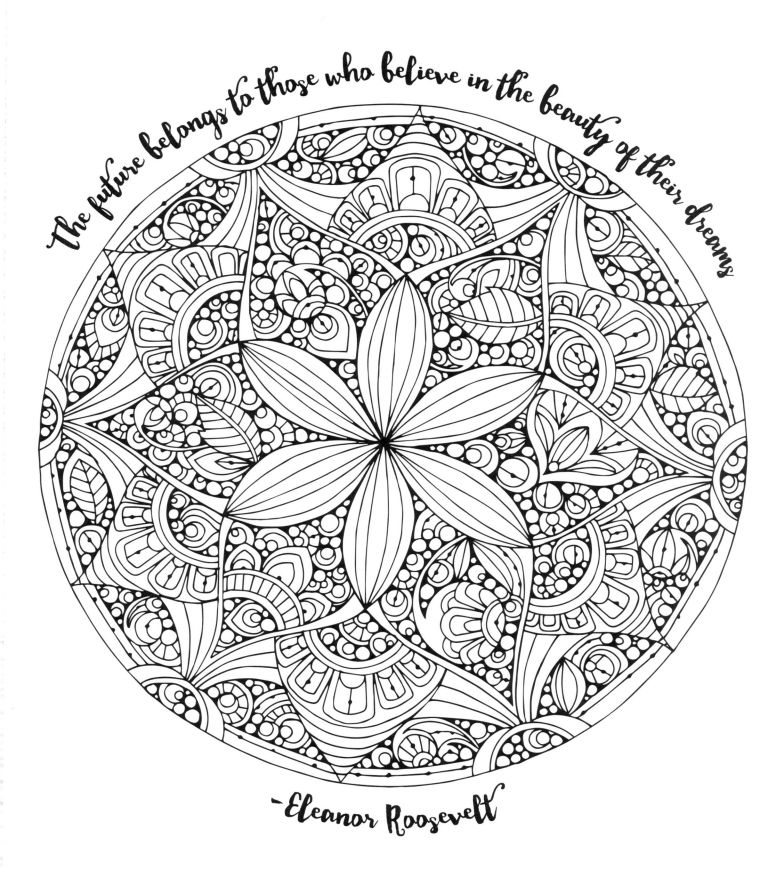

The future belongs to those who believe in the beauty of their dreams

-Eleanor Roosevelt

When I look into the future, it's so bright
it burns my eyes.

—Oprah Winfrey

